VALENTINO
MASTER
OF COUTURE
A PRIVATE VIEW

RIZZOLI
NEW YORK

New York Paris London Milan

VALENTINO GARAVANI

This book tells my story
from a different view......
I hope you like it
as I do

love

Valentino

Sept. 2012

CONTENTS

Introduction

Claire Catterall

Valentino represents so much more than exquisite couture. It is one of the greatest couture fashion houses, but it is also a code, a way of life — one that speaks of effortless elegance and high-octane glamour, of impeccable taste, presentation, and manners. It draws from many different sources, from Rome's dolce vita to New York's high society; from summers in Capri to Hollywood's red carpet; from the soirees of Paris to winters in Gstaad. And it encompasses a sense of intimacy and belonging, of family and friends. This book is a companion to the exhibition Valentino: Master of Couture. Rather than being a catalogue of the exhibition, illustrating the many beautiful gowns on display, it takes a different cue from the exhibition to offer a glimpse into the world of Valentino himself: *a private view*.

Valentino, unusually for a couture house, is named after the first rather than the second name of its designer. This suggests an intimacy that its designer was prescient in defining at the beginning of his career. Already a firm favourite with the Roman haute bourgeoisie in the early 1960s, Valentino expanded his client base quickly, and it soon included international society figures and famous names, many of whom became loyal and devoted friends. But it's not just his clients that Valentino counts as family. Another important part of Valentino's extended family is in the workplace. *Le ragazze* (the girls), the white-coated expert technicians who painstakingly handcraft each garment, many of whom have been with Valentino for decades, are also part of his family.

The images in this book are drawn from a number of sources, and many have never been seen in print before. They have been gathered during the process of researching and producing the exhibition. Each represents an exciting discovery uncovered during visits to the Palazzo

Mignanelli (Valentino's atelier in Rome) or the Valentino archives in Wideville, Paris, or was the outcome of a newly commissioned work for the exhibition. The portfolio of photographs by Deborah Turbeville was originally commissioned for and featured first in *Harpers and Queen* in 1993. Turbeville presented them as a gift to Violante Valdettaro, Valentino's long-standing head of press. The candid, personal photographs from Valentino's own albums are provided by Valentino and his lifelong business partner, Giancarlo Giammetti. The images of *le ragazze* are stills taken from a film made for the exhibition by Antonio Monfreda and Giorgio Horn. Filmed in Palazzo Mignanelli, the film shows *le ragazze* working on signature Valentino techniques. The portfolio of photographs by Cathleen Naundorf was commissioned specially for the exhibition. Naundorf was personally chosen by Valentino and Giammetti to shoot a series of archive garments on models at Château de Wideville, Valentino's home just outside Paris. The texts for the book are written by Alistair O'Neill and Patrick Kinmonth, who, along with Antonio Monfreda, curated the exhibition. Kinmonth and Monfreda, both longtime colleagues of Valentino, are also the exhibition's designers. Finally, the book is designed and art directed by Studio Frith, which is also responsible for the exhibition graphics. We hope that the book, its design, and its content reflect the wonder of a world glimpsed through a lens and a life lived truly Valentino style.

1932
VALENTINO GARAVANI
is born in Voghera, Italy

1957
GUY LAROCHE
invites Valentino to work at his Parisian couture salon

1952
JEAN DESSÈS
the Paris-based Greek couturier takes Valentino on as an apprentice

1950
LEAVES FOR PARIS
to study at the École de la Chambre Syndicale de la Couture Parisienne

1962
PALAZZO PITTI FLORENCE
plays host to Valentino's first collection, which receives critical acclaim

1964
JACQUELINE KENNEDY
orders several pieces of Valentino couture to wear during her year of mourning for John F. Kennedy

1961
ELIZABETH TAYLOR
commissions a toga-style dress to wear to the premiere of *Spartacus*

1960
GIANCARLO GIAMMETTI
and Valentino meet in a café on the Via Veneto; they begin working together

1967
HOUSE OF VALENTINO MOVES
into the eighteenth-century Palazzo Mignanelli at 24 Via Gregoriana

1975
READY-TO-WEAR
makes its Paris debut at the Hôtel George V

1968
JACKIE O
Jacqueline Kennedy wears a style from the Valentino White Collection to marry Aristotle Onassis

1968
THE FIRST BOUTIQUE
in Paris opens at 42 Avenue Montaigne

1968
THE WHITE COLLECTION
debuts in Spring/Summer 1968

1959
HOUSE OF VALENTINO
opens in Rome at 11 Via Condotti

1982 THE METROPOLITAN MUSEUM OF ART

in New York presents Valentino's Fall/Winter collection at the invitation of Diana Vreeland

2001 JULIA ROBERTS

receives her Academy Award wearing vintage Valentino

2011 VIRTUAL MUSEUM

is launched for Valentino Garavani

1986 CAVALIERE DI GRAN CROCE

is bestowed on Valentino, one of Italy's highest honours

2006 LÉGION D'HONNEUR

France's highest decoration is awarded to Valentino — the first Italian couturier to receive the award

2012 NEW YORK CITY BALLET

celebrates Valentino by commissioning him to design the costumes for their autumn Gala Ballet

1996 CAVALIERE DEL LAVORO

is awarded to Valentino, the Italian equivalent of a knighthood, for his services to the fashion industry

2000 LIFETIME ACHIEVEMENT AWARD

is given to Valentino by the Council of Fashion Designers of America

2008 FINAL COUTURE SHOW

by Valentino Garavani is staged at the Musée Rodin in Paris

1989 VALENTINO HAUTE COUTURE

is presented in Paris for the first time

2007 45TH ANNIVERSARY CELEBRATIONS

are held in Rome, including an exhibition at Ara Pacis and a live performance at the Colosseum

2008 THE LAST EMPEROR

documentary is released, charting Valentino's final collection

A ROSE

IS A ROSE

IS A A ROSE

IS A A ROSE

Valentino's Rose

Alistair O'Neill

Civilization begins with a rose. A rose is a rose is a rose is a rose.[1]

Gertrude Stein believed that a rose is the true symbol of poetry. She repeated the word to stress its essential sound and meaning, even though it might refer to more than one thing: a species of plant, the shape of its flower, the colour of the petals, or even the name of a woman. But sometimes something that looks like a rose, although not a real rose, reinforces the poetry of a rose all the more.

In a story perhaps more tall than true, Diana Vreeland, fashion editor of American *Harper's Bazaar*, dispatched an assistant to Paris not long after its liberation in 1945 to ask them to send proof that the French couture industry had prevailed. She requested an artificial rose, the kind made by a firm of *métiers* for a couturier. Not long after, she received one inside an envelope as a sign that such things were still possible.

The rebirth of Paris couture maintained the École de la Chambre Syndicale de la Couture Parisienne, established in 1927. To this day, the school specialises in technical training and design skills for the couture industry, and in 1950 a young Italian, Valentino Garavani, was offered a place to study there. Soon after, he was awarded a grant to work in the atelier of Jean Dessès before working for Guy Laroche. In 1959, the aspiring couturier decided to return to Rome to start his own atelier financed by his family.

One of his first designs was a pale green satin cocktail dress where the fabric coalesced above the knee into a border of roses. Like Vreeland's rose, these roses also travelled. But Valentino wished to extend the idea to mean more than just distance: he took the dress to Egypt, where he had it photographed in front of the Great Sphinx of Giza. To look at this surviving photograph drawn from the Valentino Archives in Paris is to realise that Valentino's rose is not just a symbol of couture and

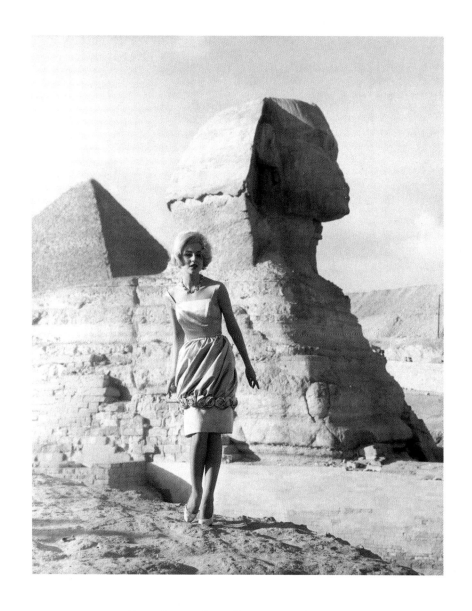

Haute Couture, Spring/Summer 1959, Cairo, 1959

continuation; from the very beginning, he wanted to show that his rose would harness the imagination, but always in deference to what stands for timelessness. Across a career spanning fifty years, Valentino's rose has always remained a rose of civilisation.

Valentino's decision to return to his home country chimed with the blossoming of postwar Italian fashion. It was the Paris models who wore Italian shoes that "used to enthuse about Rome," he once recalled, "and that really pushed me." Milan was starting to be known as a centre for *confezione* — ready-made clothing; Florence was established as a centre for accessories and leather goods; and Rome was known for its concentration of couture businesses, such as the Fontana sisters, Roberto Capucci, and Contessa Simonetta Visconti. Many of these ateliers catered to the class of Romans who still lived in palazzos, but they also worked for the Italian film industry based in Rome, producing wardrobes of costumes. The number of foreign films made in the city meant that actresses, many of them American, also became clients. Valentino first came to the attention of Elizabeth Taylor on one of her off-set shopping expeditions during the filming of *Cleopatra* (1963).

Even though Valentino emerged from the era of "Hollywood on the Tiber,"[2] the relation of his career to film is much closer. A chance meeting with the man who was to become his business partner, Giancarlo Giammetti, at a café on the Via Veneto on 31 July 1960, was in the exact section of road that Federico Fellini had selected to be re-created as a set at Cinecittà Studios for the shooting of his film about contemporary Rome, *La Dolce Vita*. They may well have seen the scandalous film first, released in February of that year, but their rendezvous cemented their shared interest in watching and being seen — the kind of looks and looking from behind dark glasses at café tables that gave birth to the paparazzo, the celebrity photographer. And this sense of constantly being on camera fully captures what Valentino stands for: always being camera-ready is designed into the

15

clothes. Speaking to André Leon Talley for *Women's Wear Daily* in the seventies, Valentino commented:

> *To dress stars or empresses is very pleasant because their concept of high fashion remains so pure. Every moment of the day is equally important, so clothes are chosen with that in mind.*

And this conveyance of a faultless presentation — what the French call soigné — is also traced in the figure of Valentino himself and the lifestyle he embodies. To look at the photographs of Valentino's world contained here — the well-known faces, the china, the etiquette, the pug dogs, and the table settings — is to appreciate them not just as symbols of generated wealth, but for their attention to appearances as the art of a highly choreographed lifestyle.

And if they look like stills from a film, it is because Italian filmmakers have long dealt with this subject matter, not as mere production design, but as a manner of appreciating the material customs of society as a way of living. Valentino learnt this early on from Michelangelo Antonioni when he was invited to supply Monica Vitti's cocktail dress for *La Notte* in 1961. The scallop-pleated flutes that twist down it offered just the appropriate amount of suggestiveness for the daughter of the host of a private soirée.

But these representations of la dolce vita are very far from the true work of a couturier, which takes place behind closed doors without the presence of cameras. Valentino's atelier, housed in Palazzo Mignanelli, near to the Spanish Steps, remains the longest-standing Roman couture house, now over fifty years in business.

While Valentino's atelier is run on lines similar to Paris couture, there are notable differences. Rather than naming the atelier departments as *flou* (French for *dressmaking*) and *tailleur* (*tailoring*), they use the terms *leggero* (Italian for *light*) and *pesante* (*heavy*). In the early days, they even had a third department for middle-weight fabrics, although they now tend toward the distinction of *super leggero* (*ultralight*), in acknowledgement

of how the weights of fabrics have become much lighter. The *premières* (principal technicians) liaise between the couturier and the hand workers, referred to in Paris as *les mains* (the hands), but at Valentino they are known as *le ragazze* (the girls). They liken this process to a conversation, a continuing exchange which turns a sketch, a piece of fabric, or talk about a silhouette into the makings of a couture outfit in toile form. Although Valentino only started showing haute couture in Paris in 1989, they have maintained the tradition of using Paris *métiers* workshops from the outset: to this day, they still turn to the firm of Lesage for embroideries and to Lemarié for featherwork.

In a sense, this Italian couture house has a greater connection to Paris than Milan, but this should not obscure the centrality of Rome as the eternal city. This sobriquet expresses the belief first made by ancient Roman poets that the city would go on forever. But to the atelier, it has another meaning — the time to think about creation. Unlike other centres of fashion, Rome prides itself on taking time to do things: to recognise the beauty of the city in the morning light, to notice the colours of the day, or to feel the *Ponentino*, a light wind that blows through the city when dusk turns to night.

If Rome has inspired Valentino couture, it is in how the city has been regarded as a palimpsest, as a document that is continually being overwritten, and as a city containing all its pasts. To look at the span of couture made by Valentino is to recognise that there are recurring themes and variations, preoccupations and proportions. The couturier crystallised this when he said, "I only believe in slow changes in fashion, which we call an evolution, not a revolution." While these might on the surface seem the preferences of Mr. Valentino, they are in fact the true lifeblood of the hand skills of the atelier; a continuing knowledge about how to make the finest and most fitting clothes without recourse to machines, in acknowledgement of an older order for making. Like a palimpsest, these techniques are employed over and over again,

whereby the knowledge of what was made before seeps into the next thing to be made.

Nearing his retirement, Valentino expressed in an interview that the continuing relevance of couture lies in applying its age-old techniques to new forms of expression: "You need old-school people who can act in the new world." Since then, Maria Grazia Chiuri and Pierpaolo Piccioli have taken the reins of the atelier to continue Valentino couture. But the old-school tradition that allows the evolution to move onward equally stays with those who hold it in their hands — *le ragazze* (some of whom have been working at the atelier for over thirty years). Therefore, the future of Valentino couture lies in the continuing thread of couture techniques that the atelier is known for. For the occasion of the exhibition Valentino: Master of Couture at London's Somerset House in 2012, the curators wished to be able to demonstrate some of these skills to visitors. One of the techniques is a set of roses turned from a length of tulle, as a sign that such things are still possible.

[1] *Civilization begins with a rose. A rose is a rose is a rose is a rose. It continues with blooming and it fastens clearly upon excellent examples.*

(Stein, Gertrude. 1954. *As Fine as Melanctha, 1914–1930.* New Haven: Yale University Press.)

[2] "Hollywood on the Tiber" was a nickname given to Rome's Cinecittà Studios around this time.

IN THE ATELIER

BY DEBORAH TURBEVILLE

Photographs, 1993

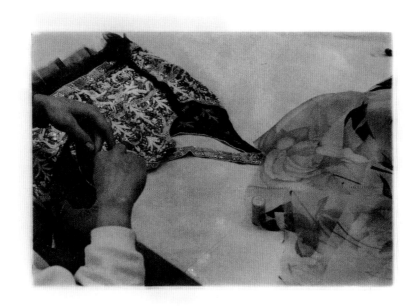

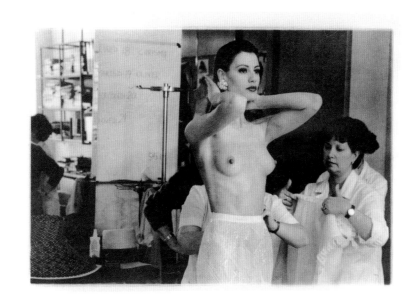

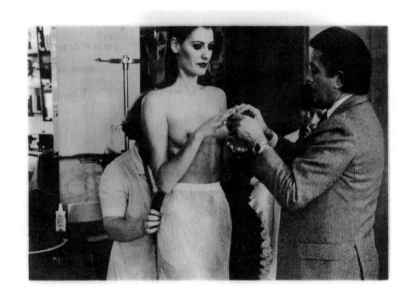

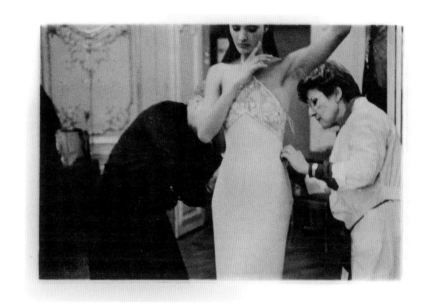

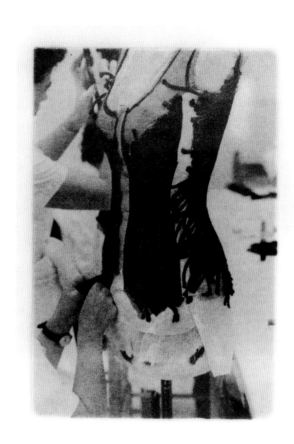

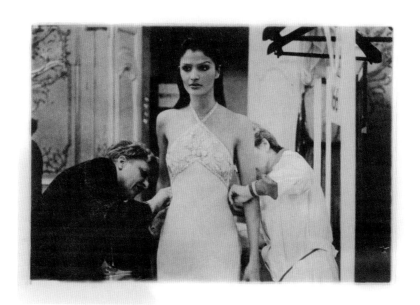

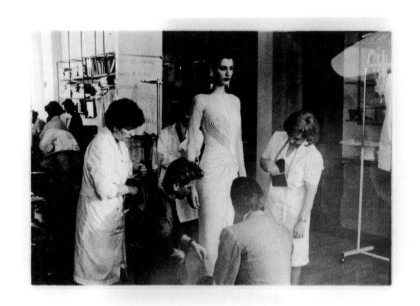

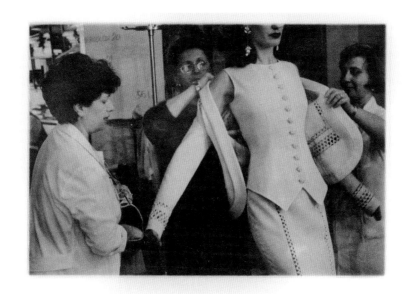

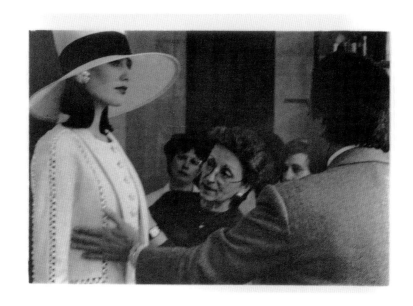

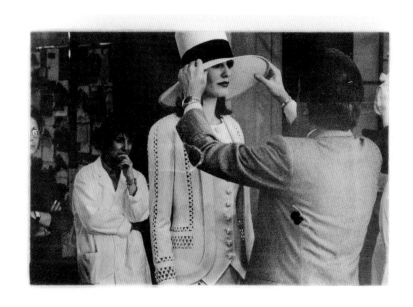

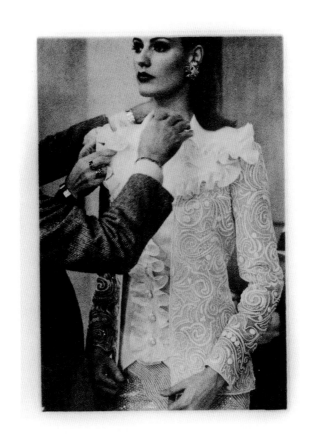

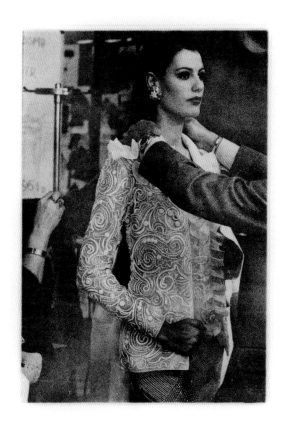

PHOTOGRAPHS FROM THE PRIVATE ALBUMS

Photographs, c.1960–1985

Rome, 1977

Rome, 1977

Rome, 1977

Valentino at home, Rome, 1972
Photo: Pierre Boulat

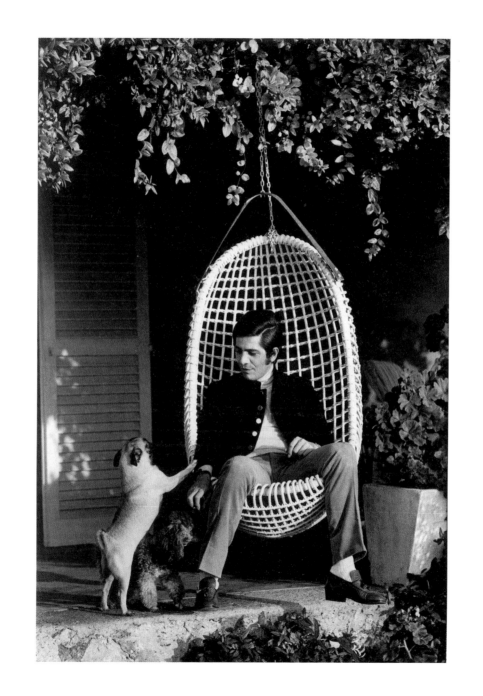

Valentino with model, Rome, 1960

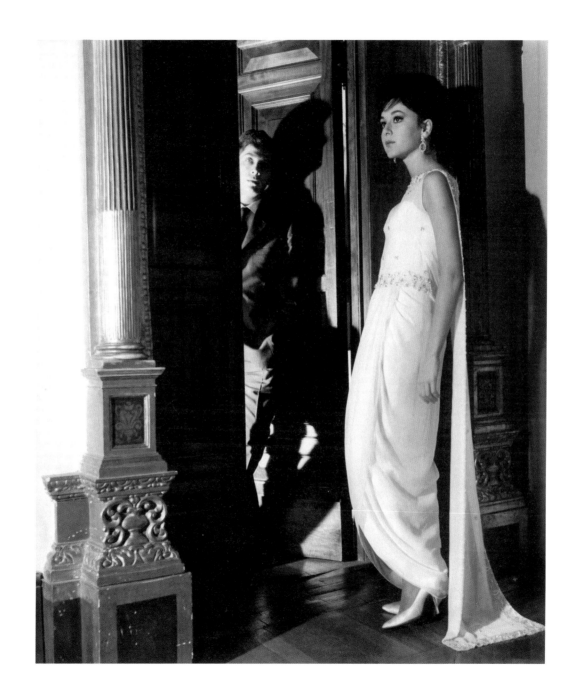

Rome, 1966

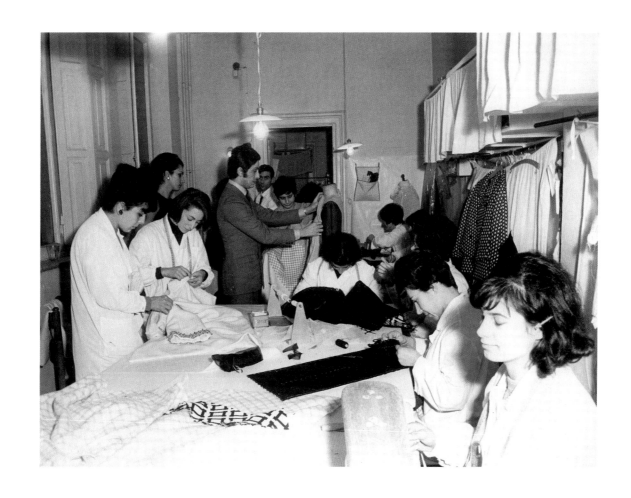

Valentino with le ragazze, Rome, 1966

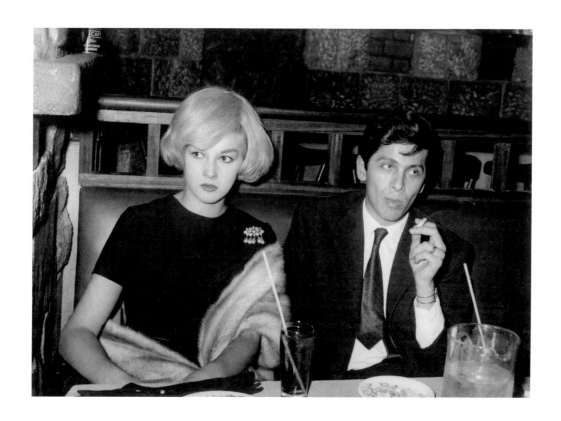

Valentino with model Carla, Rome, 1959

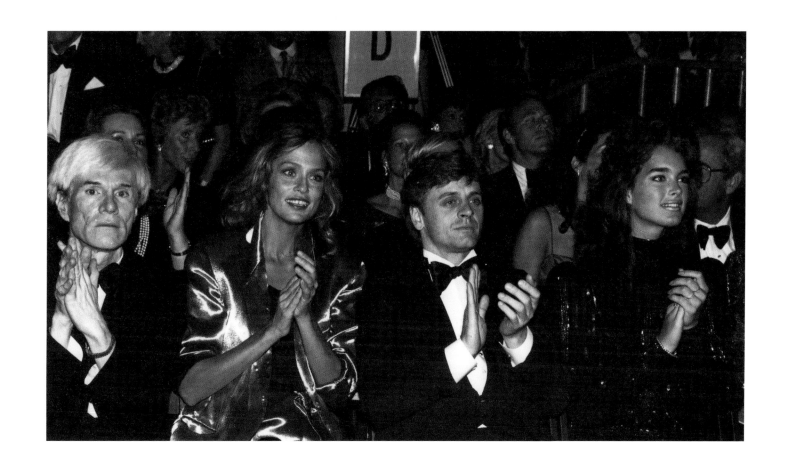

Andy Warhol with Lauren Hutton, Mikhail Baryshnikov, and Brooke Shields,
Metropolitan Museum of Art, New York, 1982

49

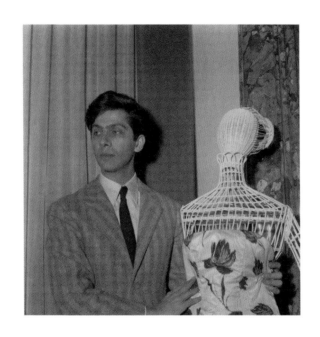

Above *Valentino, Rome, 1960*
Opposite *Valentino with Iman, Rome, c.1982*

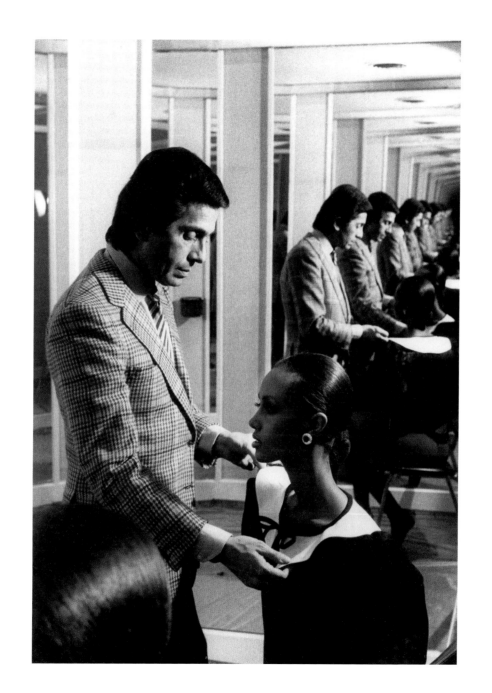

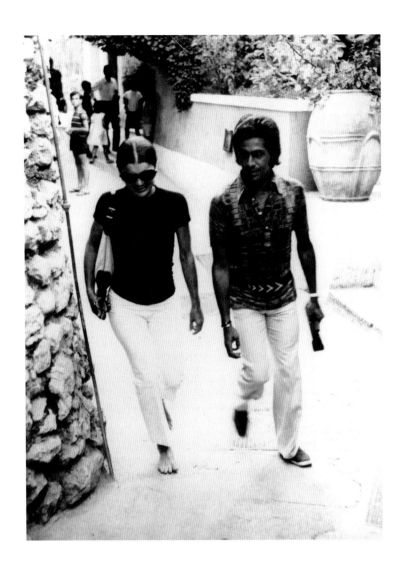

Valentino with Jacqueline Onassis, Capri, 1970

52

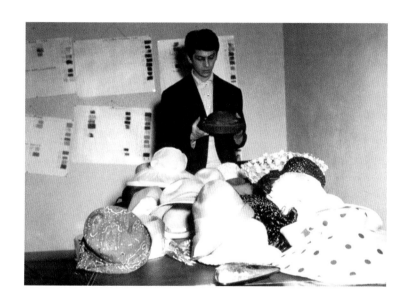
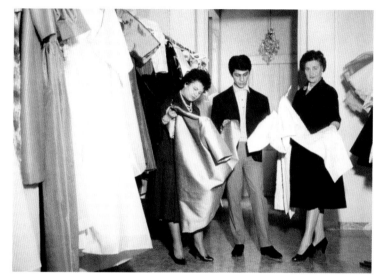

Valentino, Rome, 1960

53

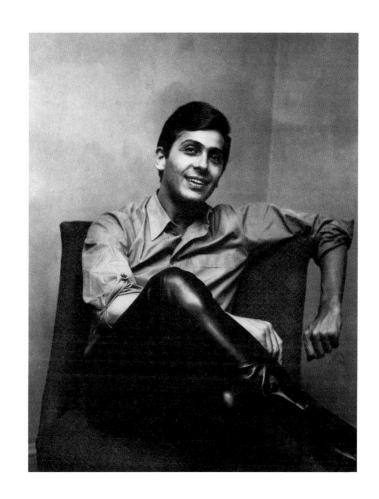

Valentino, New York, 1962

55

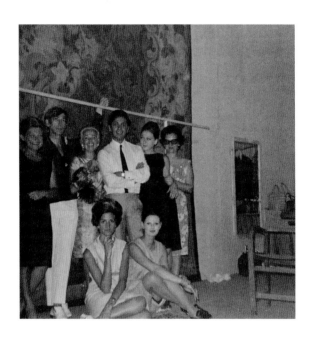

Valentino, Florence, 1964

56

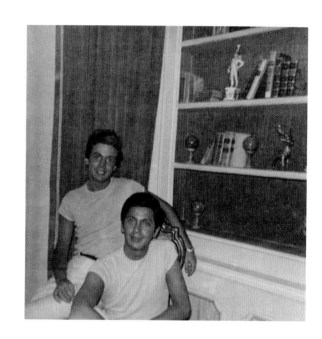

Valentino and Giancarlo Giammetti, Rome, 1964

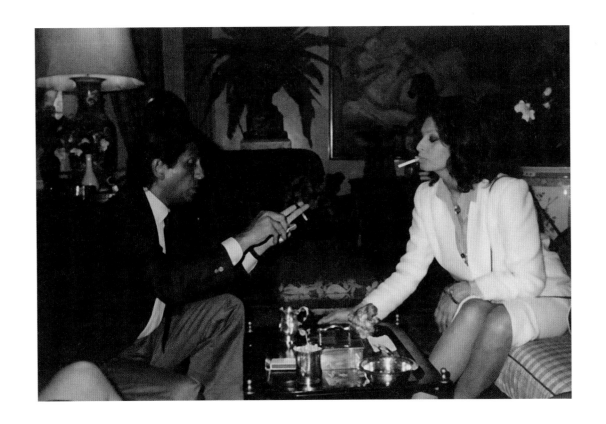

Valentino with Sophia Loren, Rome, 1983

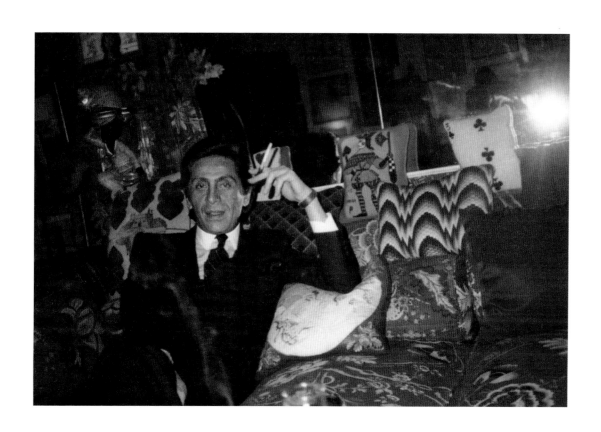

Valentino at Diana Vreeland's home, New York, 1981

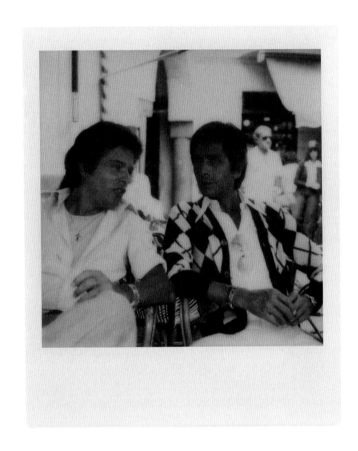

Valentino with Giancarlo Giammetti, Capri, 1984

60

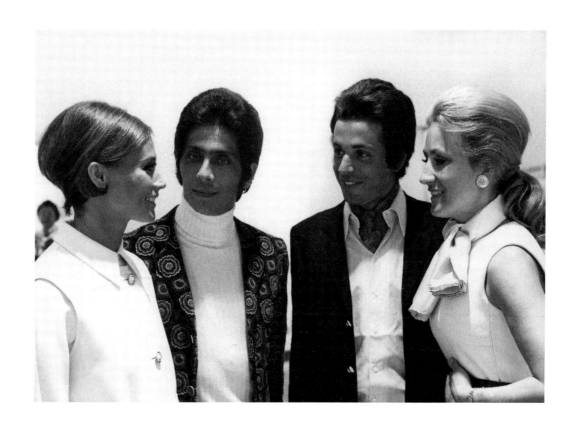

Valentino and Giancarlo Giammetti, New York, 1970

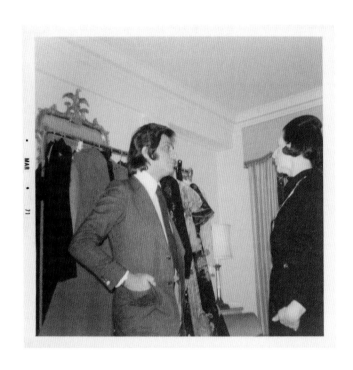

Valentino with Diana Vreeland at Hotel St. Regis
New York, 1971

62

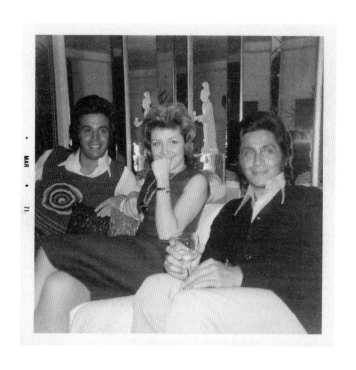

Valentino with Giancarlo Giammetti and Paola Azzali at home
New York, 1971

63

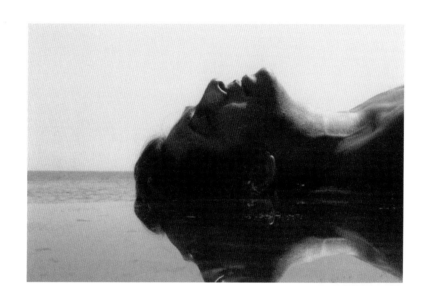

Valentino on yacht Talifu, Capri, 1972

65

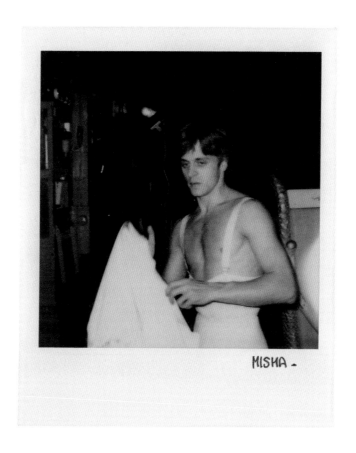

MISHA -

Mikhail Baryshnikov at Théâtre des Champs-Elysées, Paris, 1978

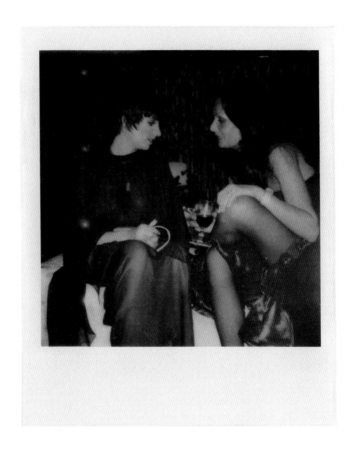

Liza Minnelli and Diane von Furstenberg, Los Angeles, 1977

68

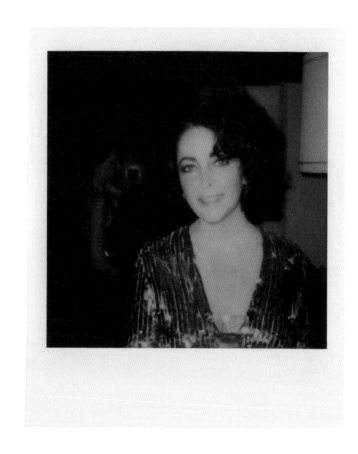

Elizabeth Taylor, Gstaad, 1976

69

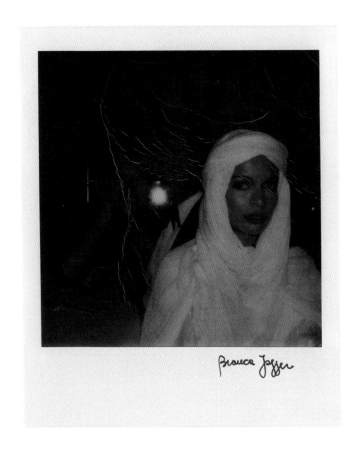

Bianca Jagger, New York, 1975

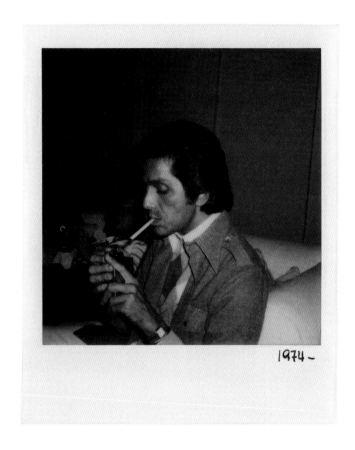

1974

Valentino at home, New York, 1974

71

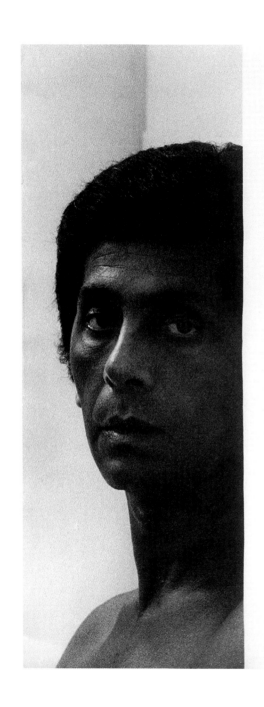

Valentino at home, Rome, 1980

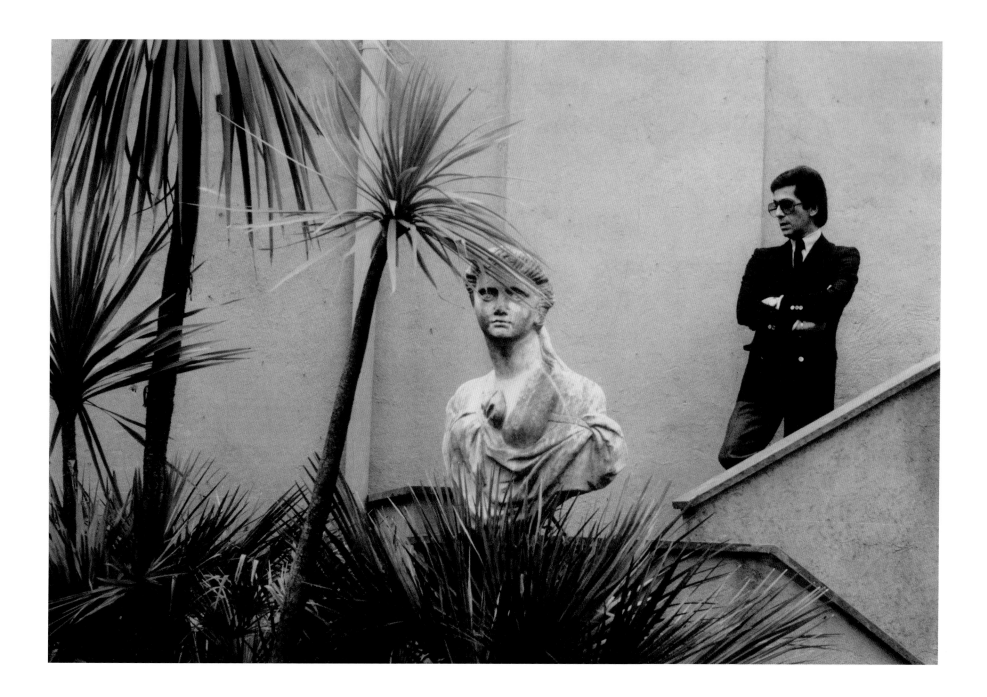

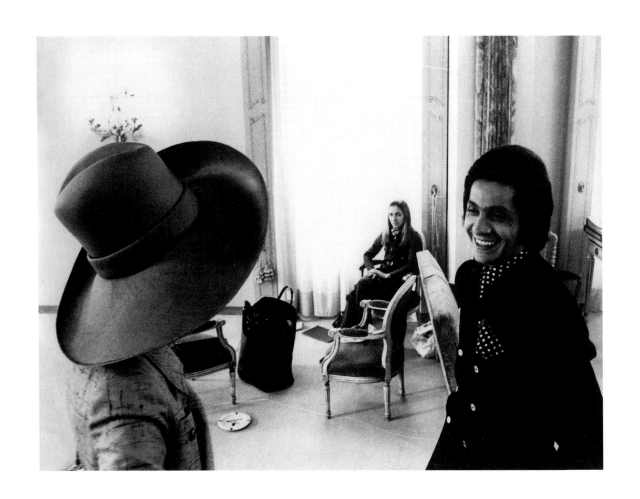

Valentino with model, Rome, 1974

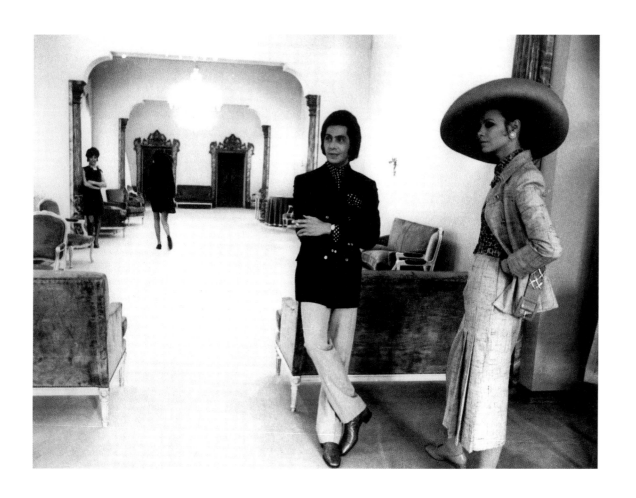

Valentino with model, Rome, 1974

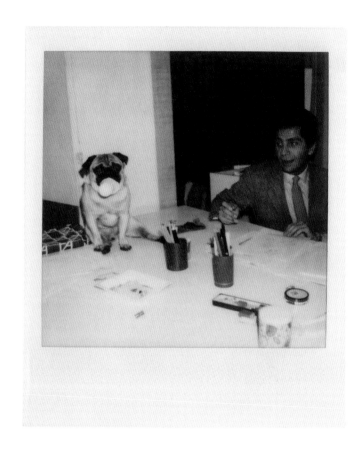
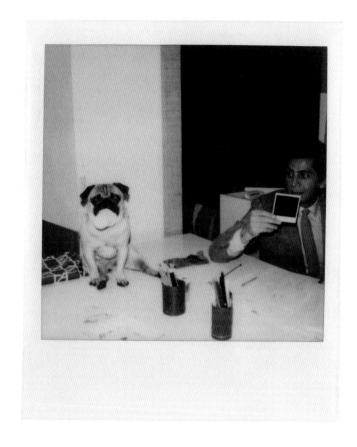

Valentino in his office with pug Oliver, Rome, 1980s

79

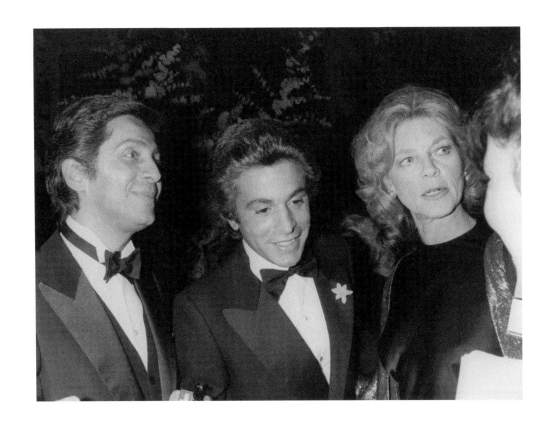

Valentino with Giancarlo Giammetti and Lauren Bacall, Paris, 1978

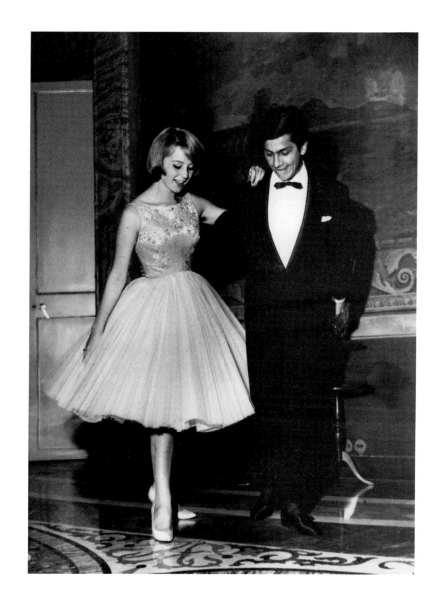

Valentino with Sandra Panaro, Rome, 1960

Valentino, Venice, 1980

Valentino, Rome, 1981

84

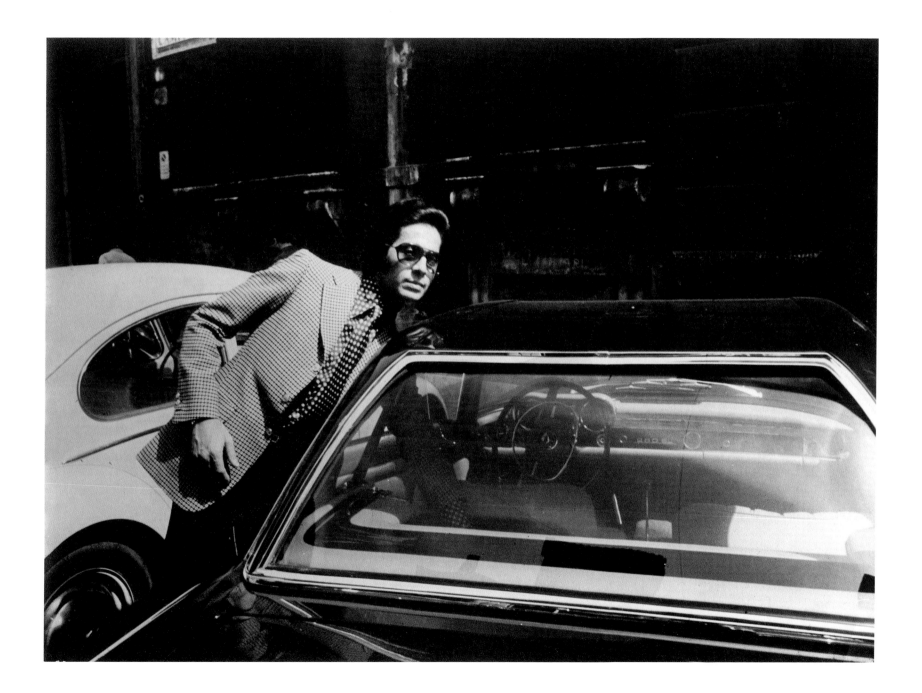

LE RAGAZZE DI VALENTINO

Photographs by Antonio Monfreda
and Giorgio Horn, 2012

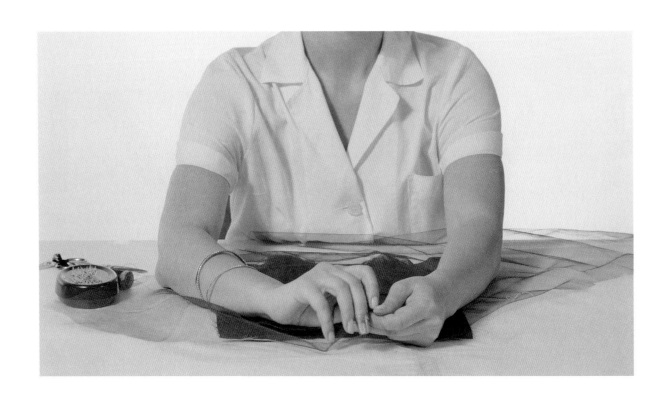

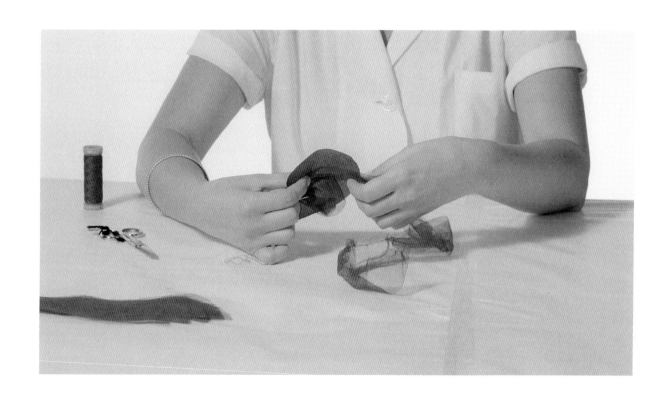

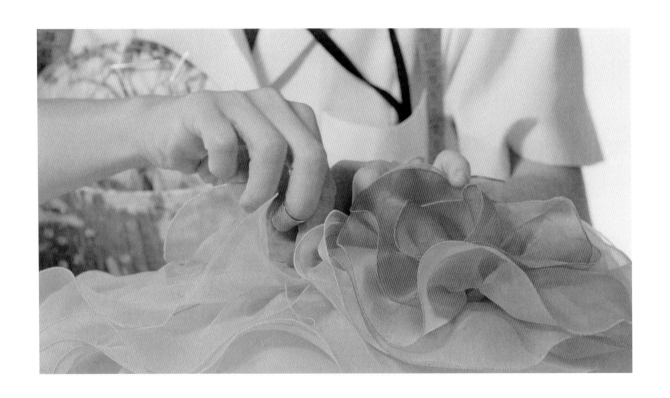

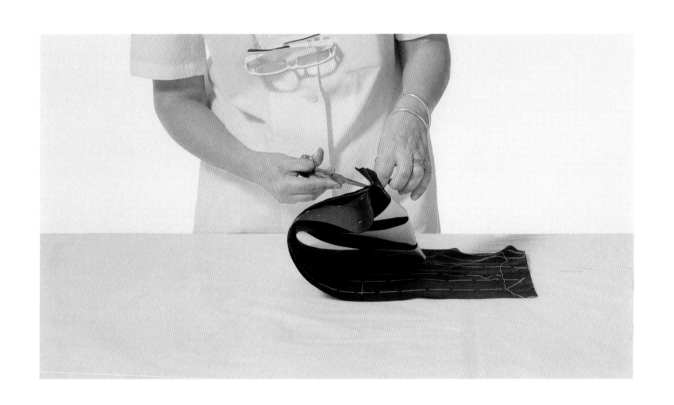

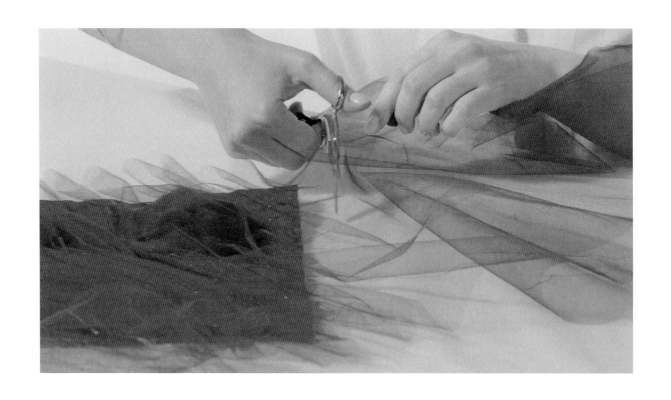

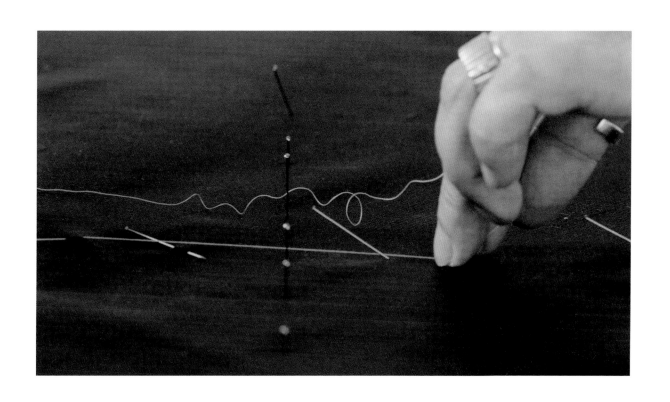

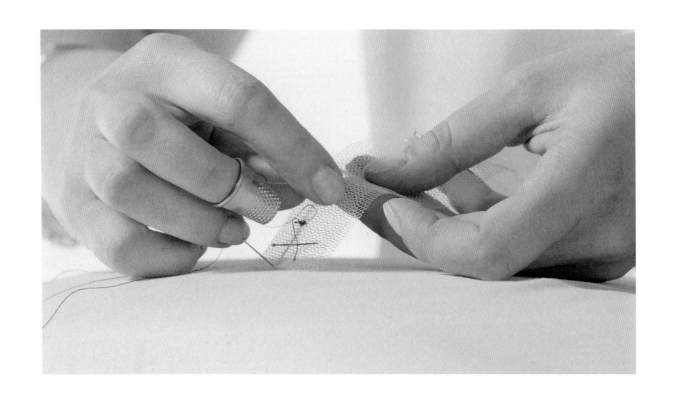

94

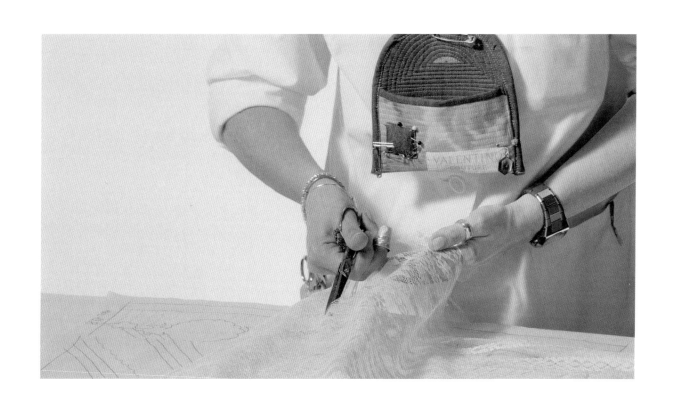

AU CHÂTEAU DE WIDEVILLE

Photographs by Cathleen Naundorf, 2012

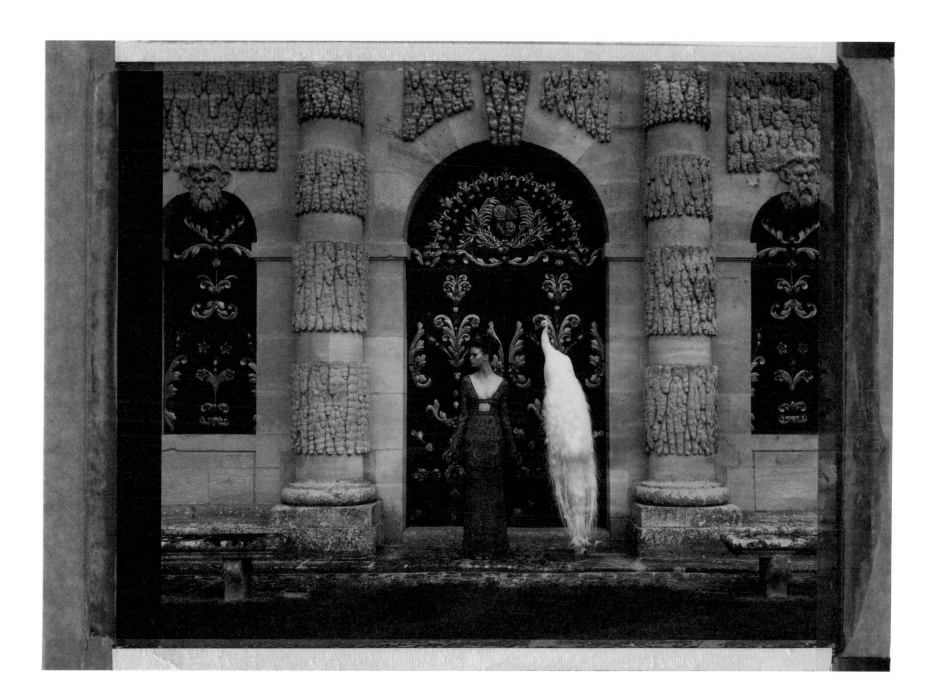

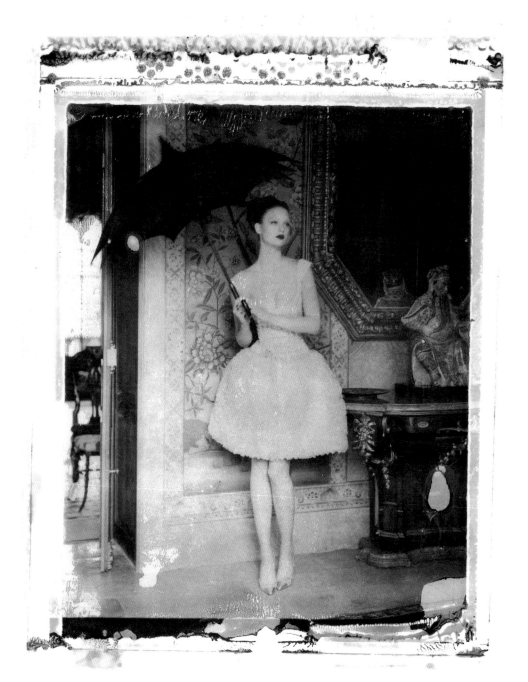

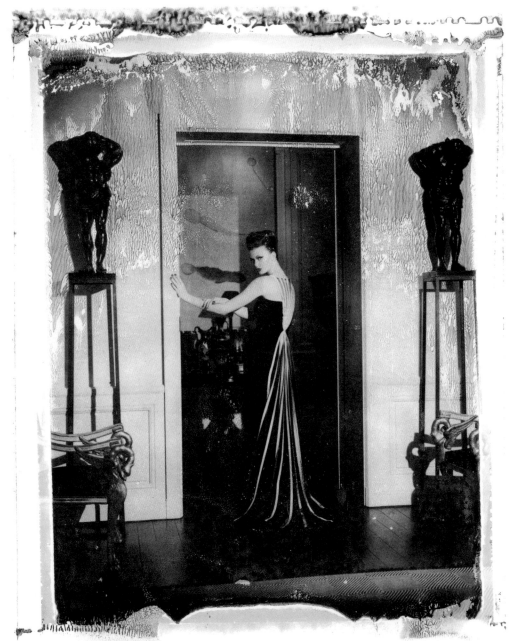

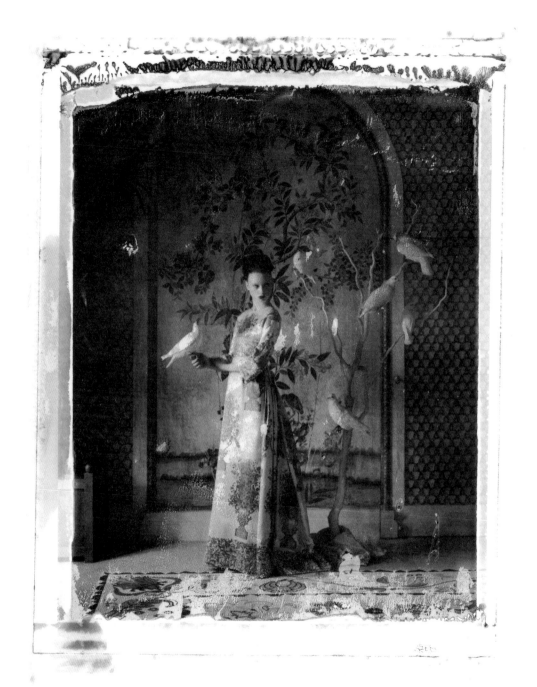

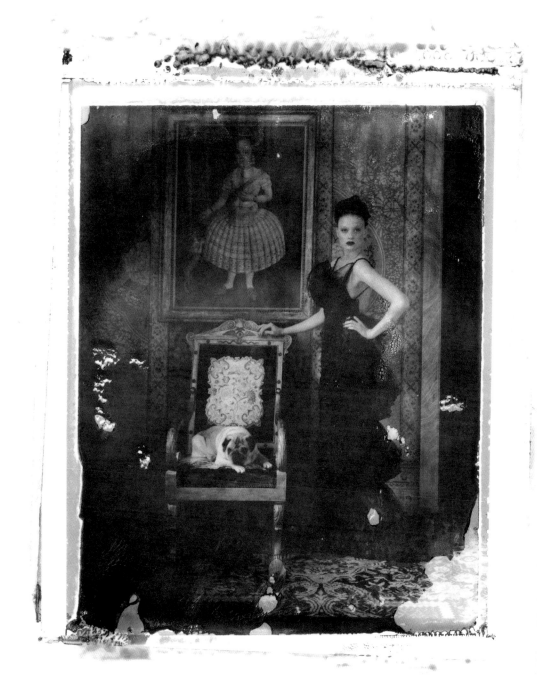

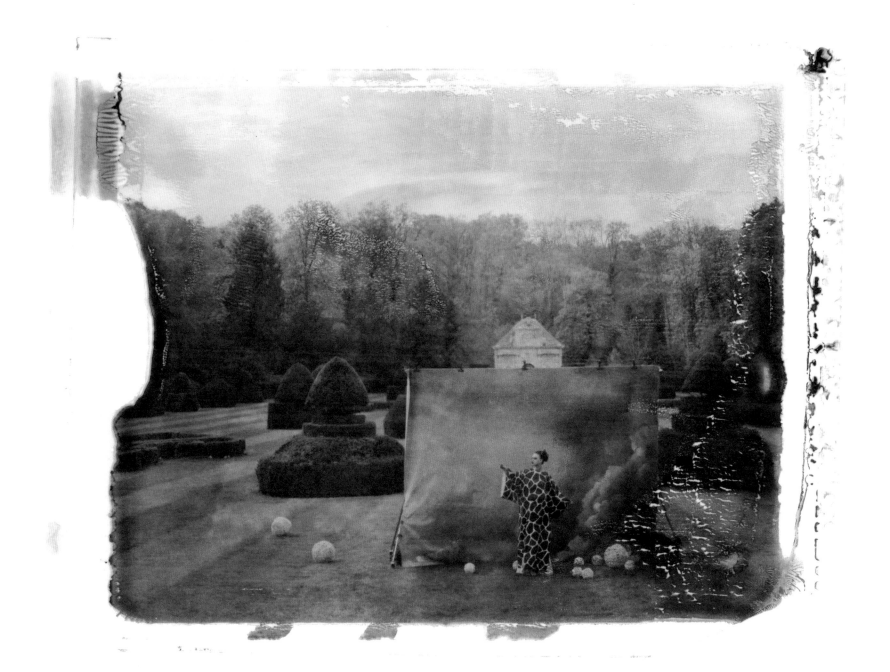

Rome, Paris, London, New York

Patrick Kinmonth

Four capitals of fashion, four distinct cultures, and the four cornerstones of Valentino's career.

In Rome, home to his ateliers and the crucible in which he brought to life his distinct vision of la dolce vita, the workshops have not stopped producing his magical clothes for half a century, with every stitch by hand. Somewhere in Valentino's HQ, Palazzo Mignanelli, like the spinning wheel in the turret room in the tale of *Sleeping Beauty*, there is apparently a pile of sewing machines gathering dust. They have never been used...

In Paris, the city which above all has celebrated Valentino's sensibility, and where clothes assume their proper importance as part of art and culture, he has been hailed as the king of Italian couture. And whilst London is less a city of couture than a theatre of self-expression, it is a place where fashion is a vehicle for revolution and for the expression of individuality. Here, clothes can assume the power of politics in a country whose definitive sartorial revolutions from punk to street to the hunt and the track have always been refined, appropriated, and transmuted by couture into a sometimes equivocal homage to our freedom and self-assuredness. Valentino has always loved London and greeted its eccentricity with an answer as elegant as it is strong: beauty for its own sake.

In fact, Valentino's Italian soul, fierce visual intelligence, and international sensibility is equally adjusted to all four cultures and finds itself completely at ease in dialogue with Rome, Paris, London, and New York, and on the reddest of carpets in the world. No coincidence, then, that he has houses in all four cities — all decorated differently, pursuing aesthetic reactions to the nuances of each place, and populated by nomadic tribes of brilliant cosmopolitan friends.

In the London show, we wanted to discuss this magical relationship between friends and places, diligent craft, and expressive wonderment, and to highlight the fact that couture is the work of incredibly skilled women sewing backstage in the ateliers. Working in a way that is uniquely Italian, Roman couture surpasses another glory of Italian culture in its craft: *la cucina Italiana*. In both, it is the intervention of inspired manipulation that transforms simple, natural materials — whether silk and thread or flour and water — into art. The infinitely fine layers of Valentino's chiffons and tulles confected into roses and shells challenge their natural inspirations in terms of beauty and belie their humble origins. We wanted to show this in its true context — the catwalk — where thousands of hours of work are seen passing by in a few moments by the scrutinizing eyes of the world of fashion. But instead of a show that lasts perhaps twenty minutes, we wanted to present a catwalk of history, stretching through the golden age of couture and continuing into the present.

In the Atelier, Rome, 1993
by Deborah Turbeville

p. 20–22
Valentino Atelier, Palazzo Mignanelli

p. 23
Helena Christensen, Valentino Atelier, Palazzo Mignanelli

p. 24
Valentino Atelier, Palazzo Mignanelli

p. 25
Helena Christensen, Valentino Atelier, Palazzo Mignanelli

p. 26–31
Valentino Atelier, Palazzo Mignanelli

Au Château de Wideville, 2012
by Cathleen Naundorf

p. 99
Valentino Couture, Fall/Winter 2006

p. 101
Valentino Couture, Spring/Summer 1995

p. 102
Valentino Couture, Fall/Winter 1992/1993

p. 103
Valentino Couture, Fall/Winter 1968/1969

p. 105
Valentino Couture, Fall/Winter 2001/2002

p. 107
Valentino Couture, Spring/Summer 1966

Cover Image:
Valentino with model, Rome, 1974
courtesy of the Valentino Archives

Our most sincere thanks to Mr Valentino Garavani and Mr Giancarlo Giammetti for their kind permission to use this precious material, and for their enthusiasm and support for the project.

Special thanks also to all the individuals whose assistance and support made this book possible: Jasmine Habeler, Violante Valdettaro, Hervé Goraud-Mounier, Michela Leto, Livia Carimini, Cynthia Ventucci, Michela Sabbatini, Mark Hislop, Chiara Horn, Luca Roberti, and Charles Miers.

This publication accompanies the exhibition Valentino: Master of Couture
At Somerset House 29 November 2012 — 3 March 2013

Curated by Alistair O'Neill, Patrick Kinmonth, and Antonio Monfreda

Somerset House Team: Claire Catterall, Director of Exhibitions and Learning; Sue Thompson, Exhibition Organiser; Shonagh Marshall, Assistant Curator; Cat Smith, Exhibitions Assistant

Book art direction and design, and exhibition graphic design: Studio Frith

Exhibition design: Kinmonth-Monfreda

First published in the United States of America in 2012 by
RIZZOLI INTERNATIONAL PUBLICATIONS
300 Park Avenue South, New York, NY 10010
www.rizzoliusa.com

In association with
Somerset House, Strand, London, WC2R 1LA
www.somersethouse.org.uk

ISBN-13: 978-0-8478-4060-1
Library of Congress Control Number: 2012948952

For Somerset House
Editor: Claire Catterall

For Rizzoli
Editor: Dung Ngo
Copy editor: Matt Price

All photographs courtesy of the Valentino Archives, except for the following:
© Pierre Boulat: 41
© Antonio Monfreda and Giorgio Horn: 88, 89, 90, 91, 92, 93, 94, 95
© Cathleen Naundorf: 99, 101, 102, 103, 105, 107
© Deborah Turbeville: 20, 21, 22, 23, 24, 25, 26, 27, 28, 29, 30, 31

Printed and bound in Italy

2012 2013 2014 2015 2016 / 10 9 8 7 6 5 4 3 2 1